MW01353465

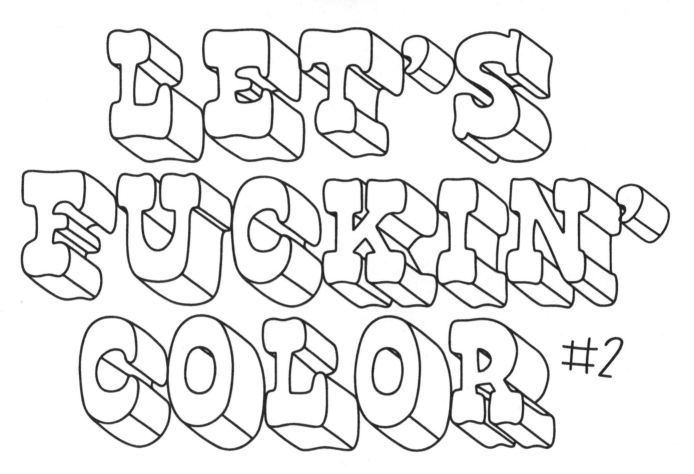

@HEARTSANDSHARTS

WWW.HEARTSANDSHARTS.COM
© 2024 HEARTS AND SHARTS
ISBN: 979-8-9904495-1-0

Hearts and Sharts

"A LITTLE CUTE, A LITTLE UNEXPECTED"

paper choice

IN ORDER TO KEEP THINGS AFFORDABLE FOR EVERYONE, THIS COLORING BOOK CONTAINS STANDARD-QUALITY PAPER. TO AVOID ANY BLEED-THROUGH WITH CERTAIN PENS AND MARKERS, SLIDE A BLANK PIECE OF THICKER PAPER BEHIND THE PAGE YOU ARE COLORING.

share your work

I LOVE SEEING THESE PAGES COME TO LIFE! WHEN YOU LEAVE A REVIEW, SHARE A PIC!

@HEARTSANDSHARTS

WWW.HEARTSANDSHARTS.COM

ALL RIGHTS RESERVED. NO PART OF THIS PUBLICATION MAY BE REPRODUCED OR TRANSMITTED IN ANY WAY - ELECTRONIC, MECHANICAL, PHOTOCOPYING OR RECORDING - WITHOUT PRIOR WRITTEN CONSENT FROM THE PUBLISHER. (THAT'S ME). SMALL EXCERPTS FOR REVIEWS ARE COOL, THOUGH.

Hearts and Sharts

A LITTLE CLUE A LITTLE MEXICERO

paper chase

IN ORDER TO KEEP THIS AS AFFORDABLE BOOK
EVERYONE THIS COLORING BOOK CONTAINS
SINGLE SIDED QUALITY PAPER. TO AVOID ANY
BLEED-THROUGH WITH CERTAIN PENS AND MARKERS,
SLIDE A BLANK PIECE OF THICKER PAPER BEHIND THE
PAGE YOU ARE COLORING.

share your story

I LOVE SEEING THESE PAGES COME TO LIFE WHEN YOU
LEAVE A REVIEW, SHARE A PIC.

@HEARTSANDSHARTS

WWW.HEARTANDSHARTS.COM

ALL RIGHTS RESERVED. NO PART OF THIS PUBLICATION MAY BE REPRODUCED,
OR TRANSMITTED IN ANY WAY, ELECTRONIC, MECHANICAL, PHOTOCOPYING,
OR RECORDING, WITHOUT PRIOR WRITTEN CONSENT FROM THE PUBLISHER.
THAT'S ME. EXCEPT STOCK REVIEWS, A FEW GOOD THOUGH.

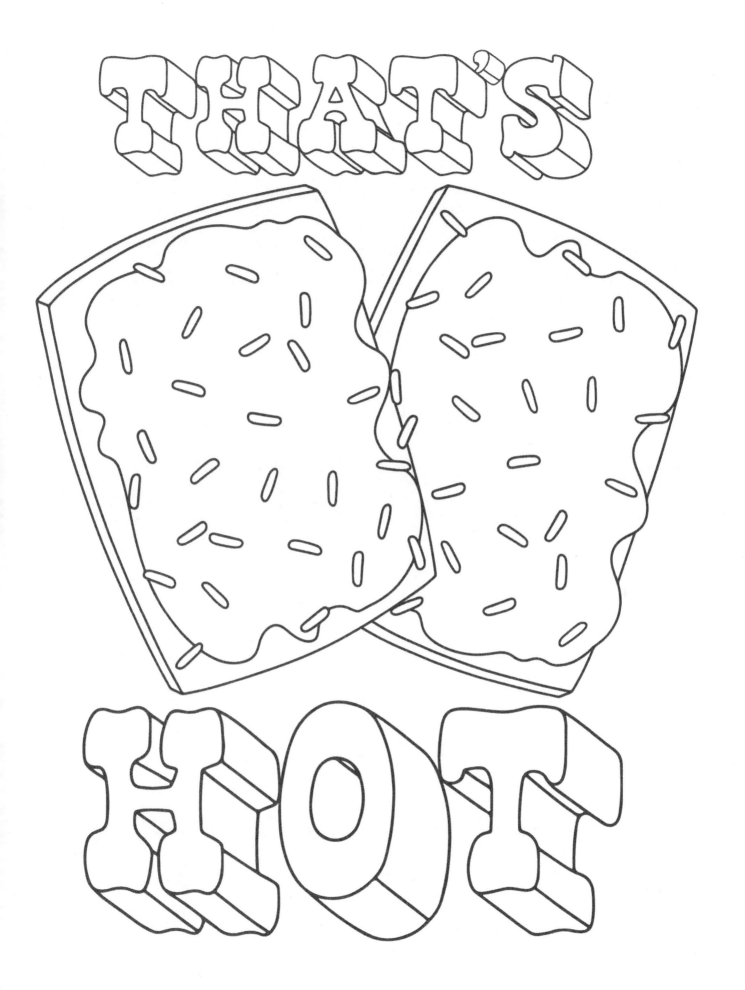

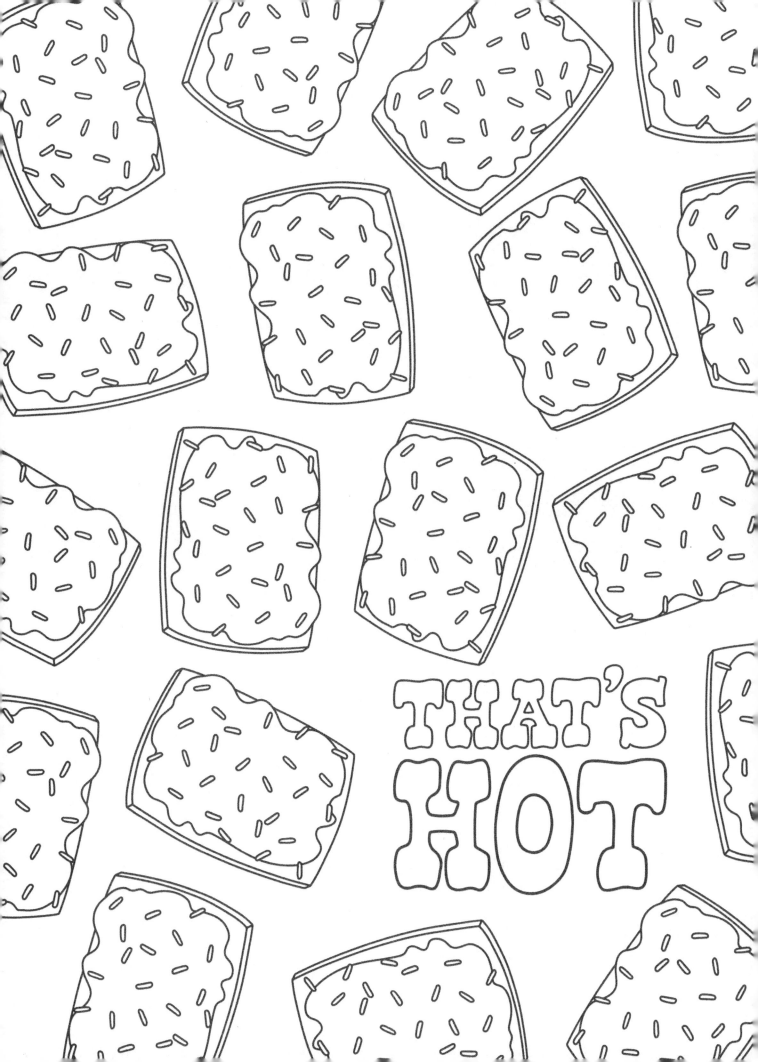

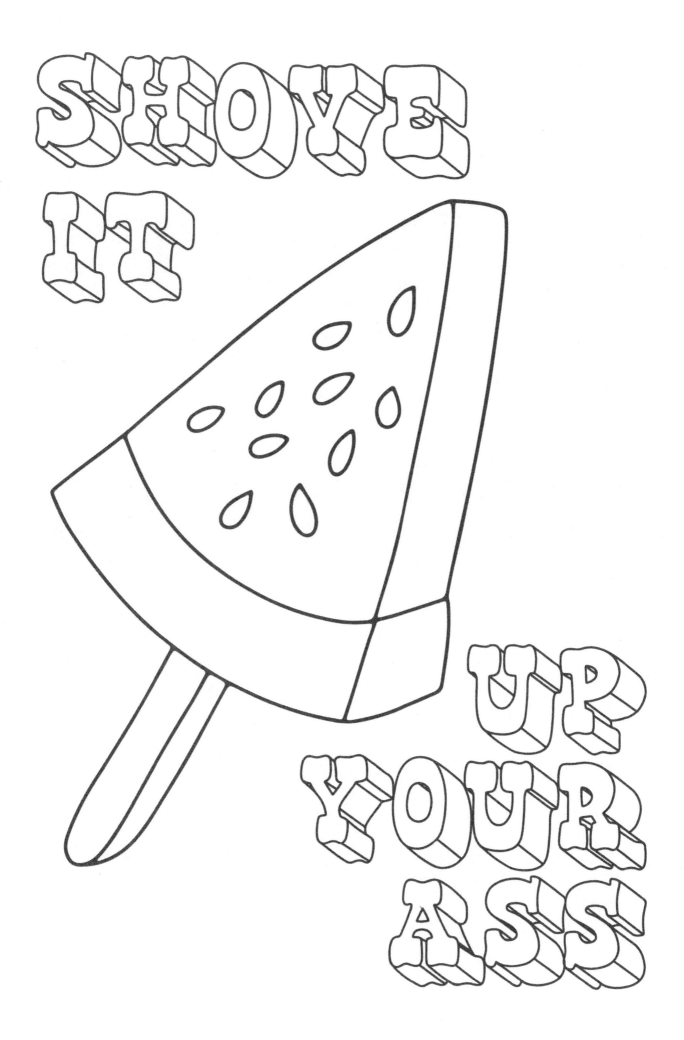

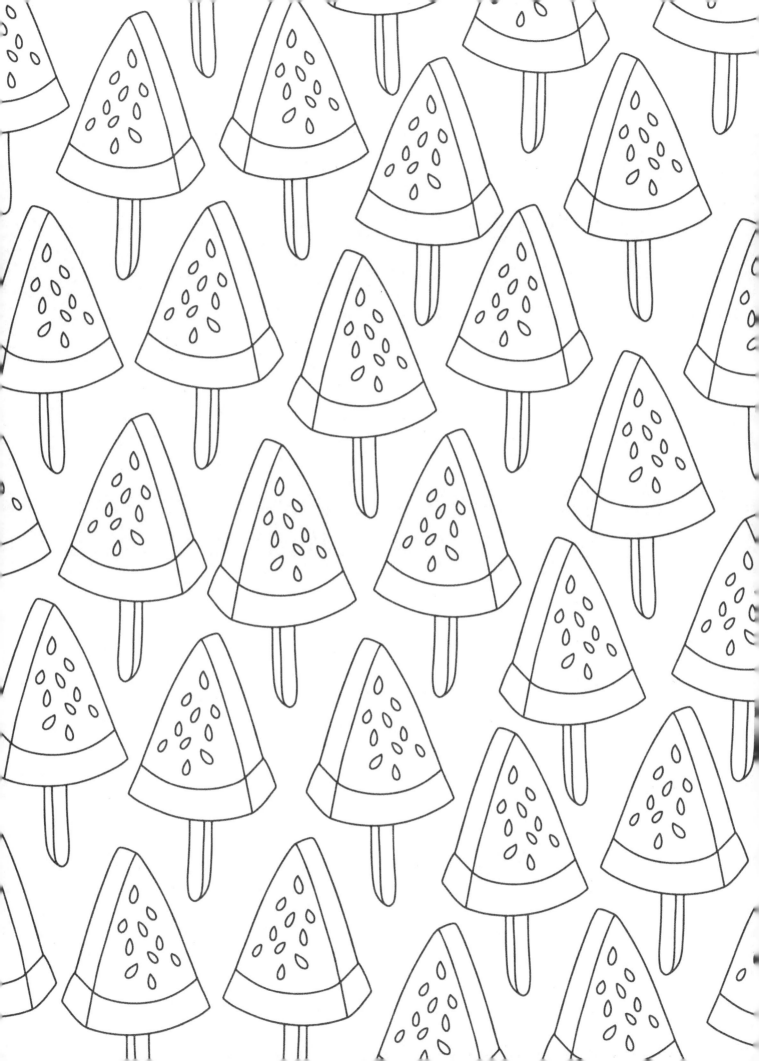

ABOUT TO GO FUCKING POSTAL

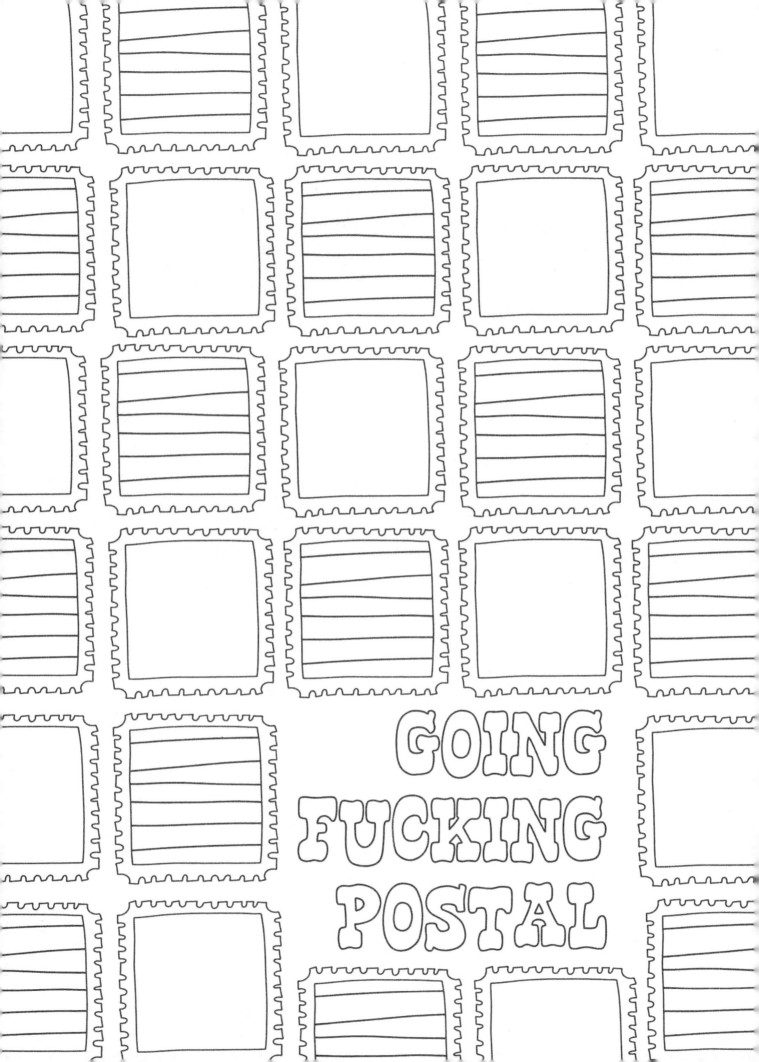

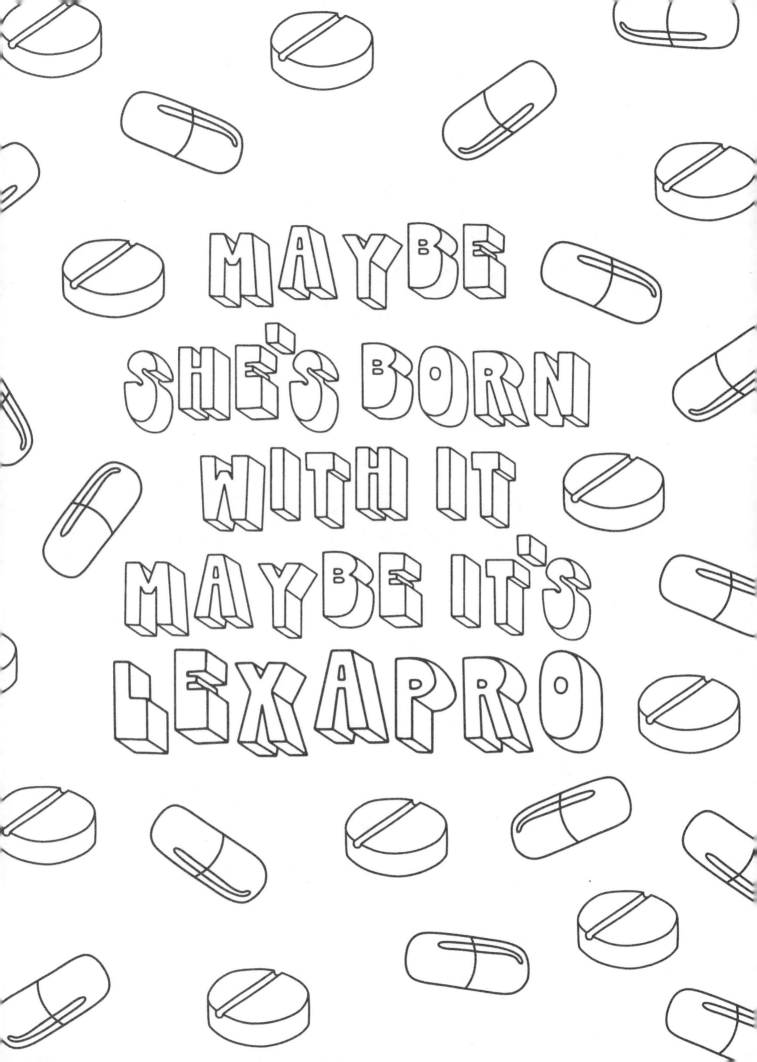

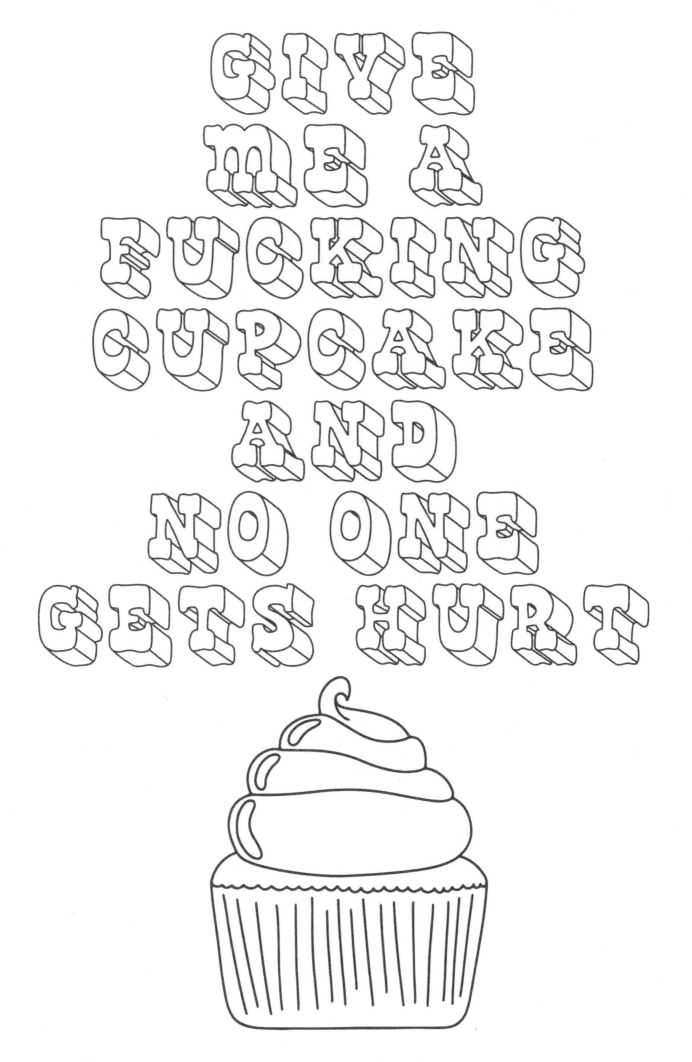

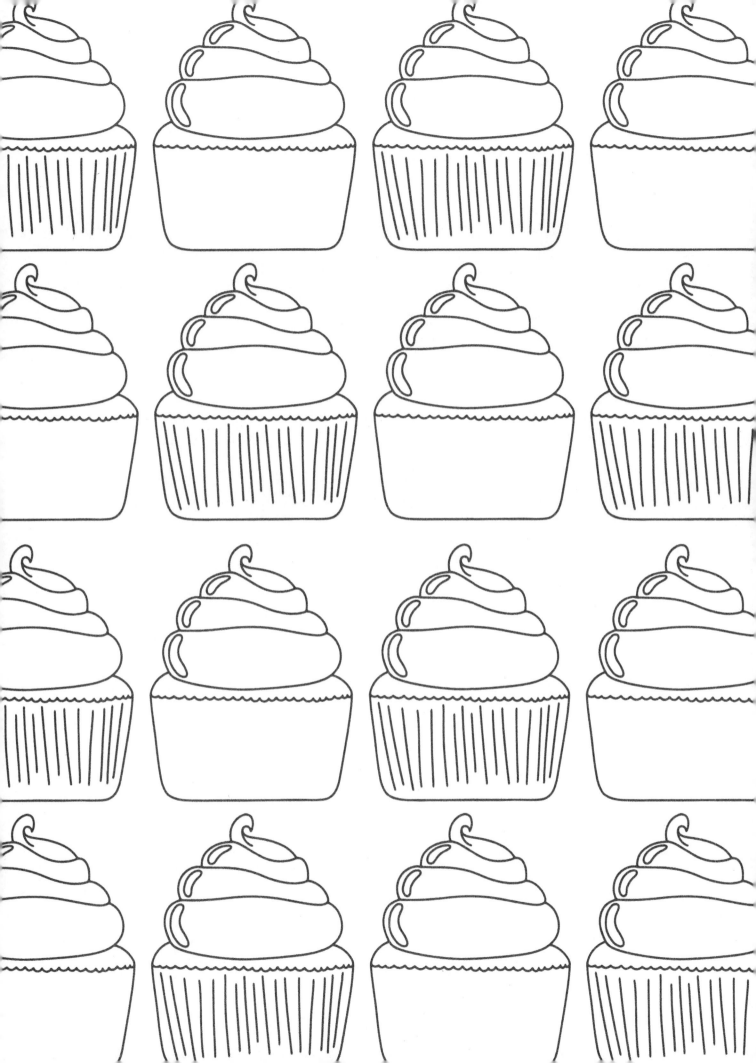

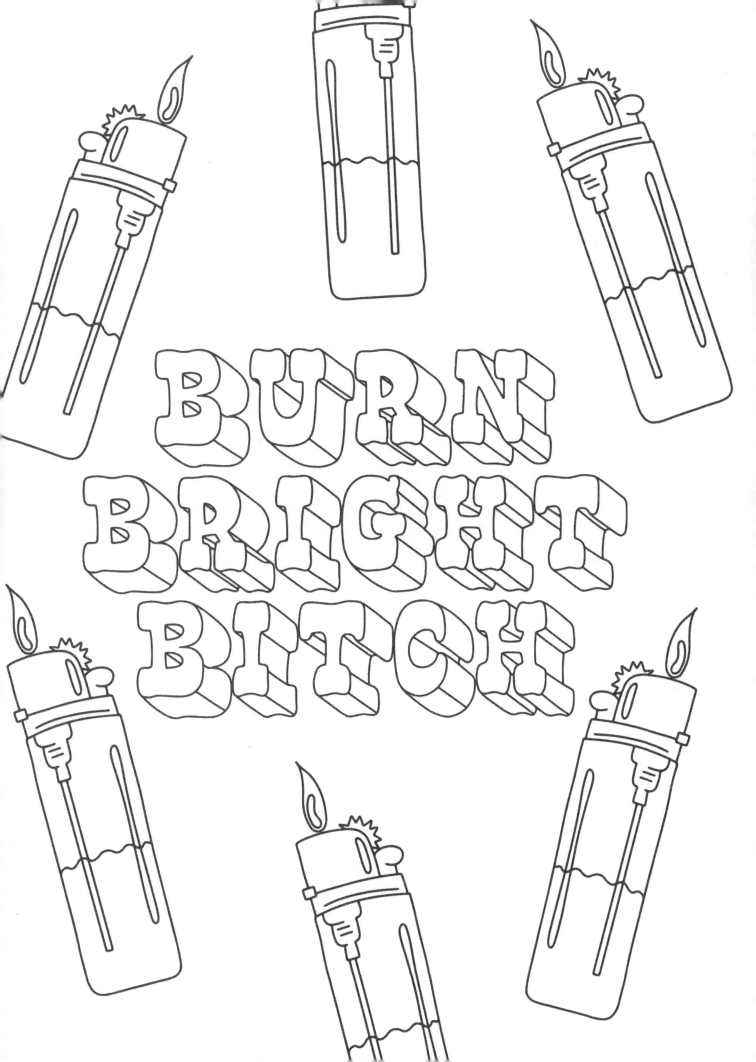

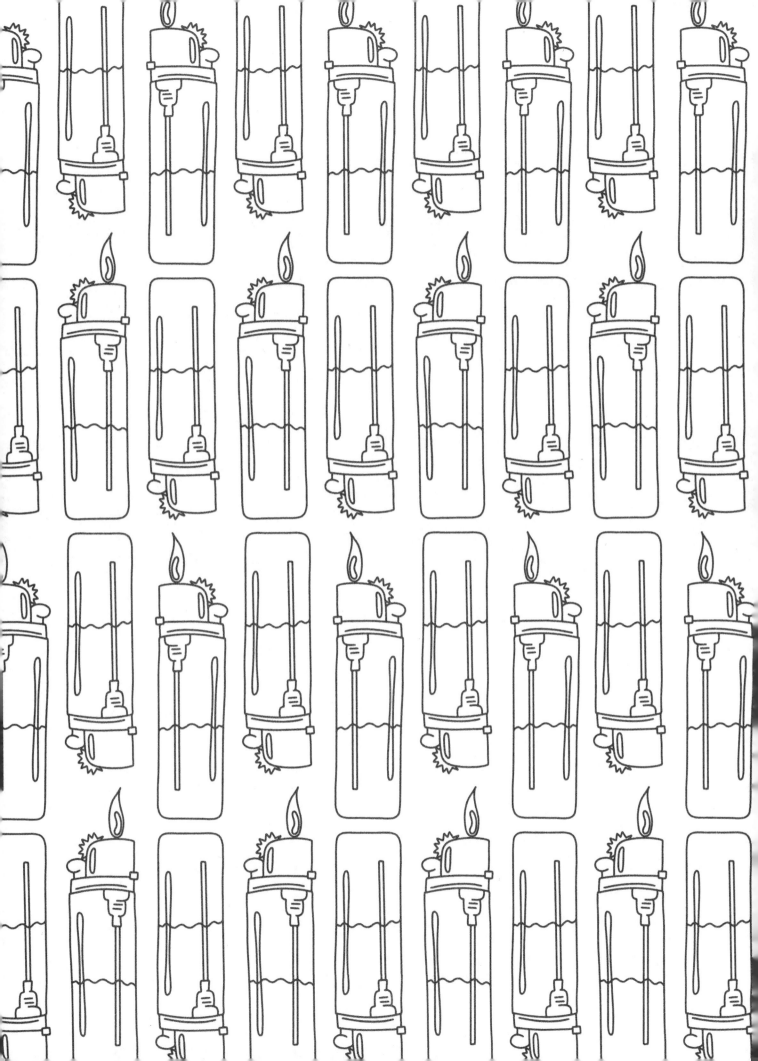

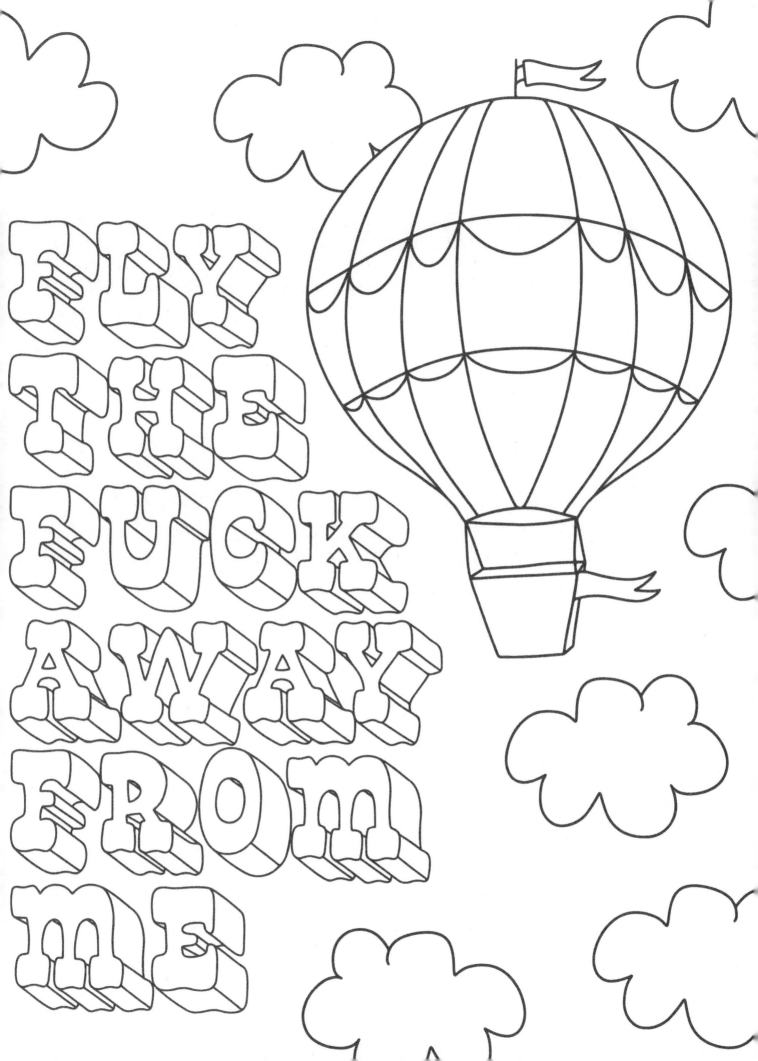

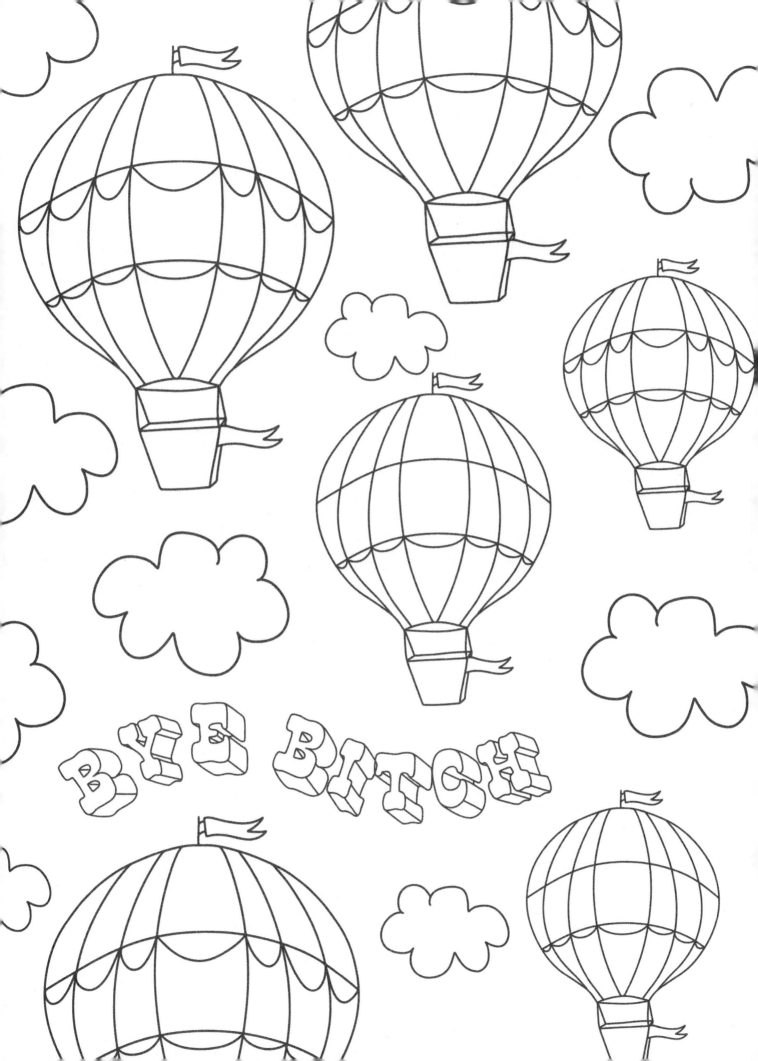

I'VE GOT
BAGGAGE

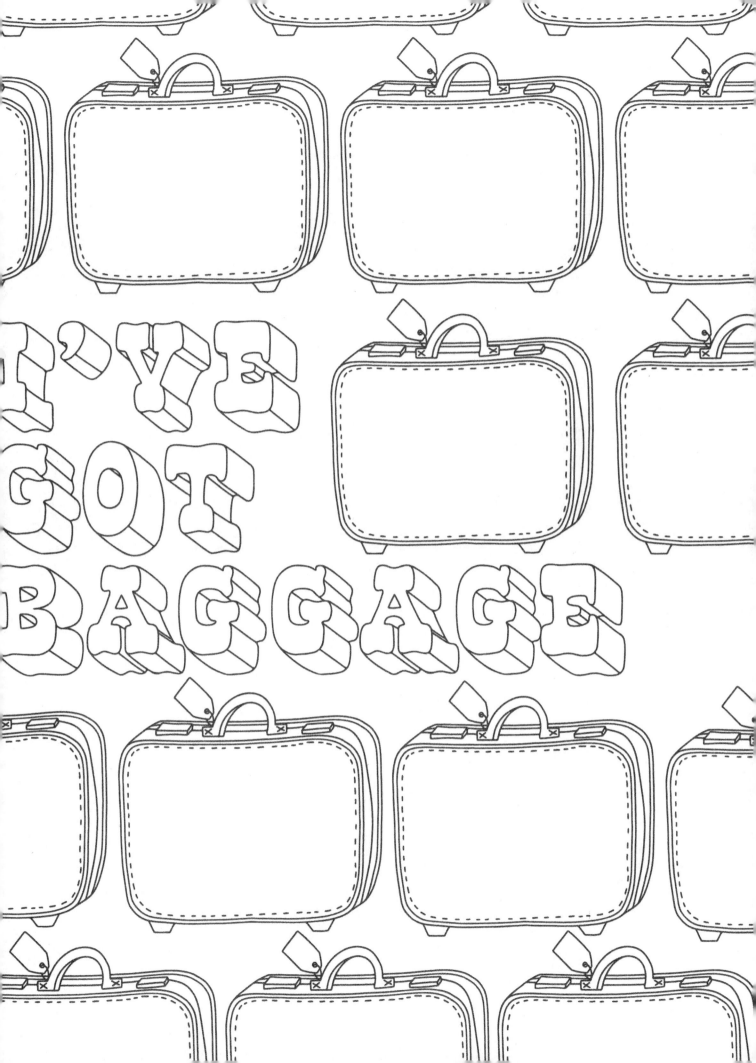

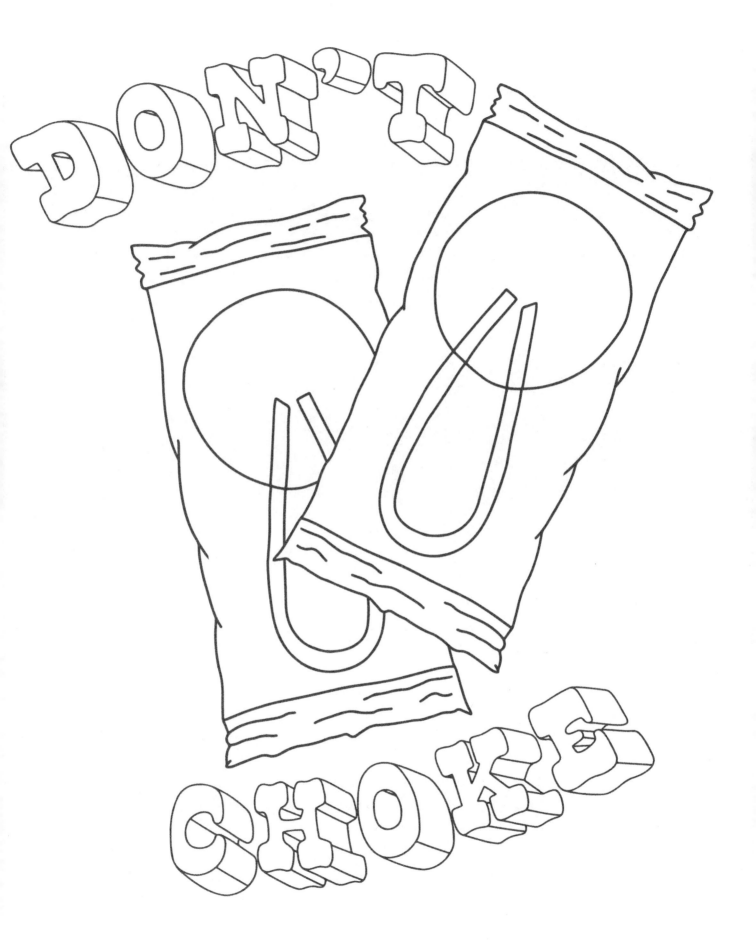

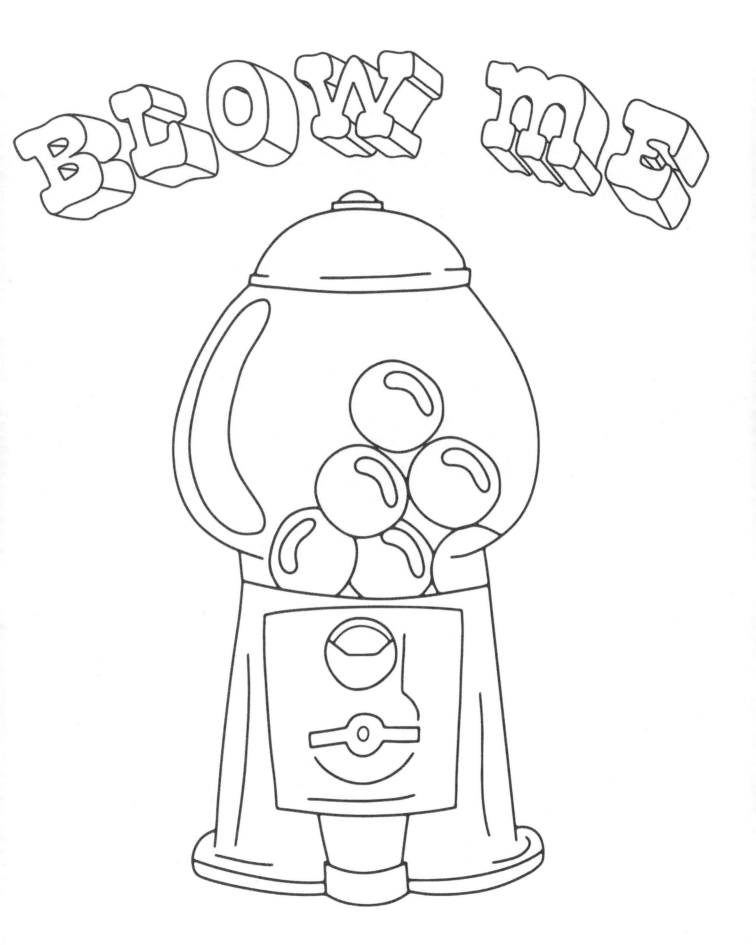

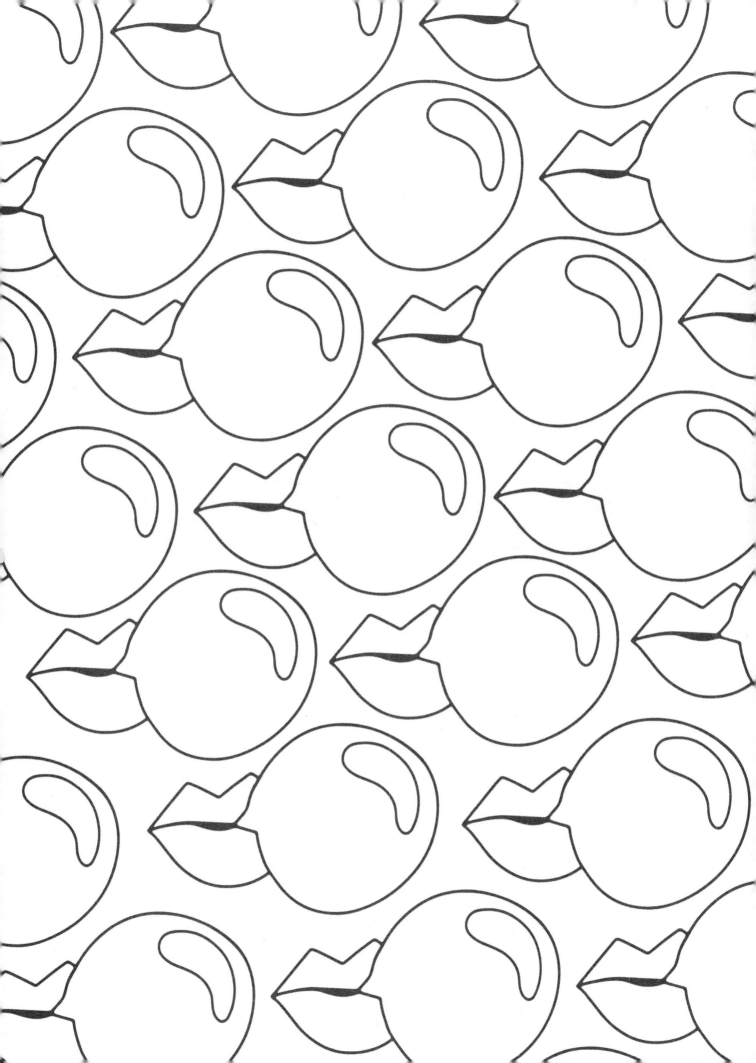

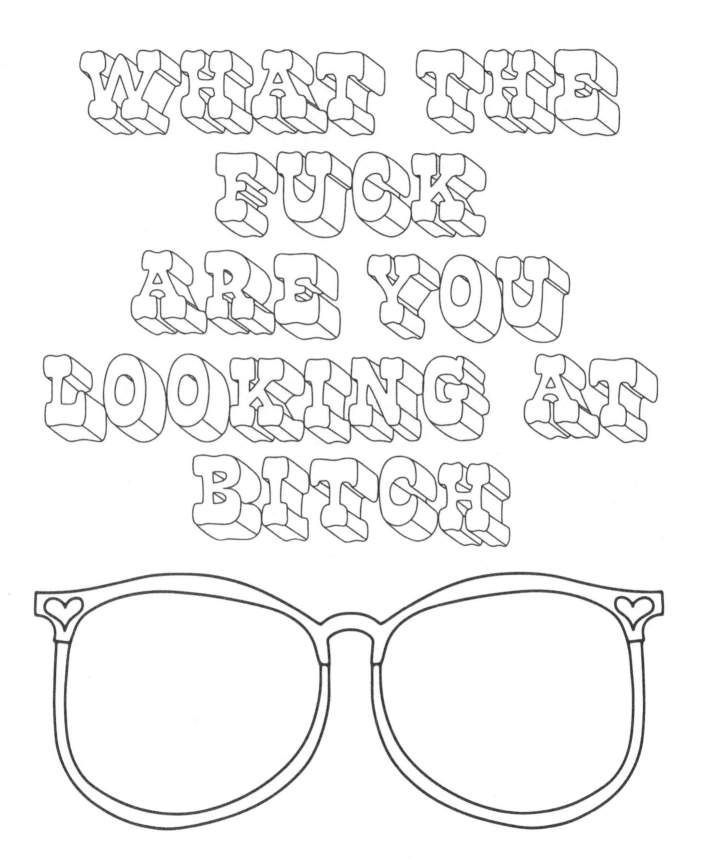

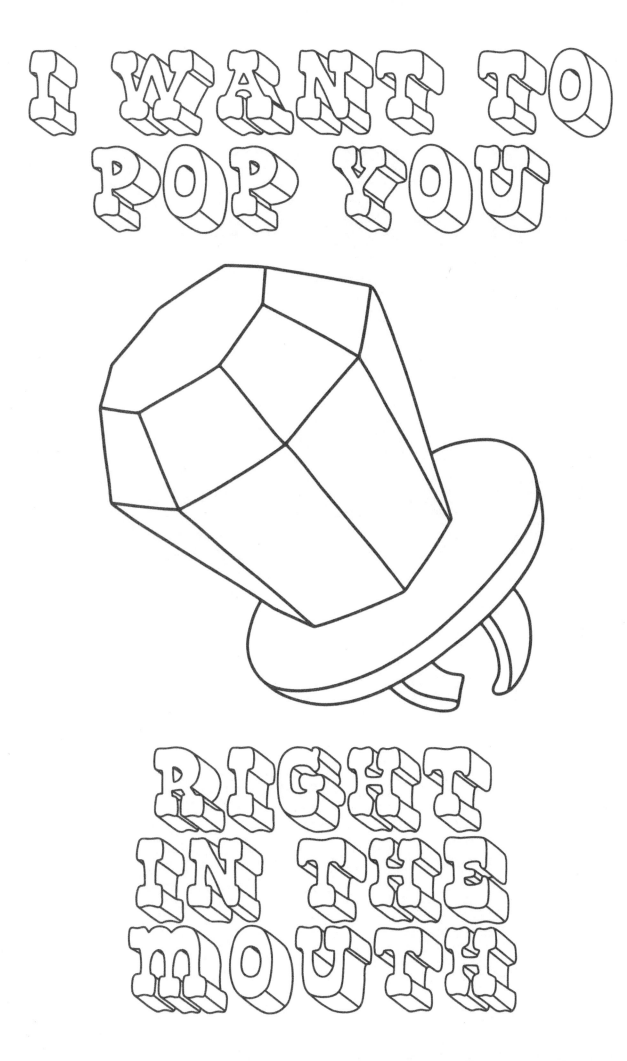

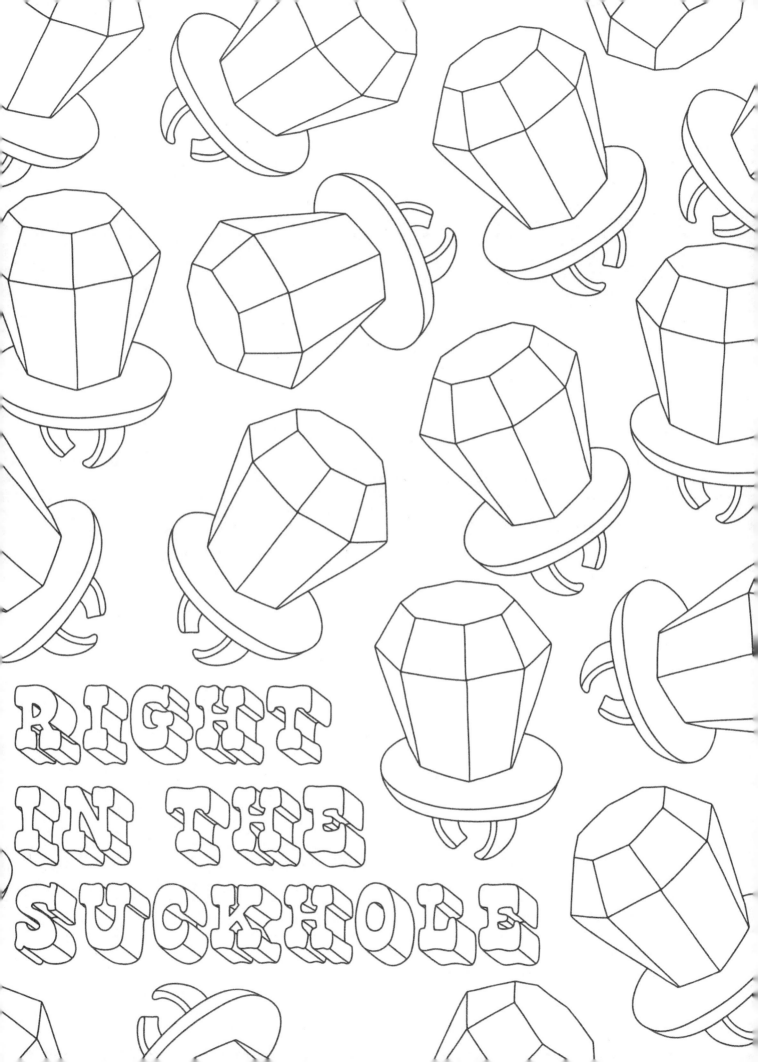

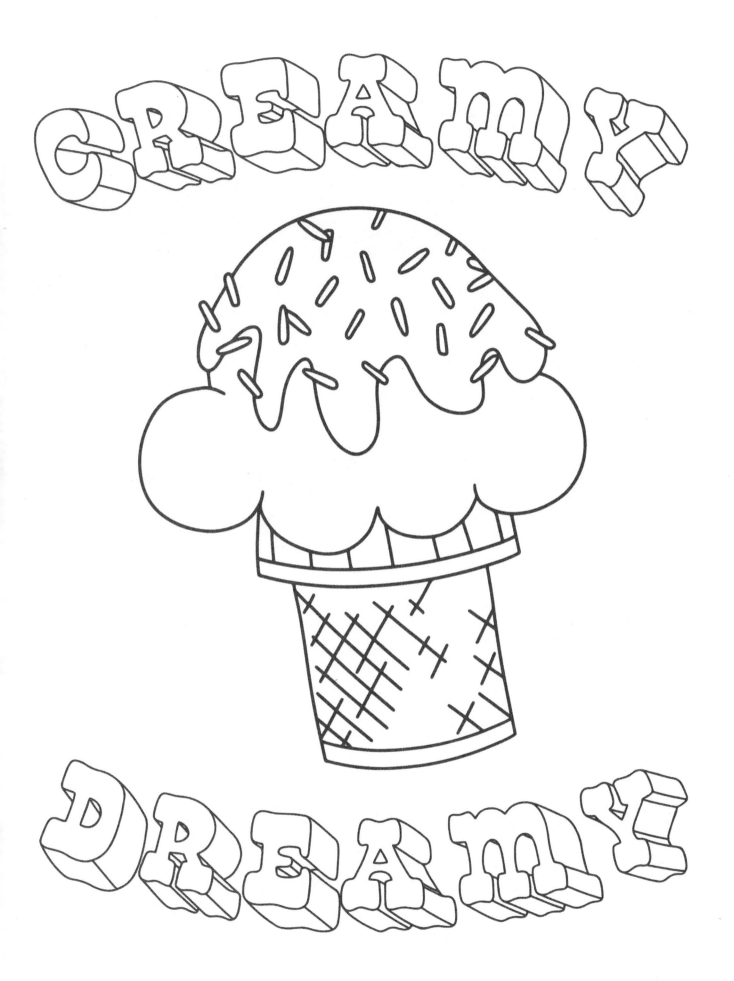

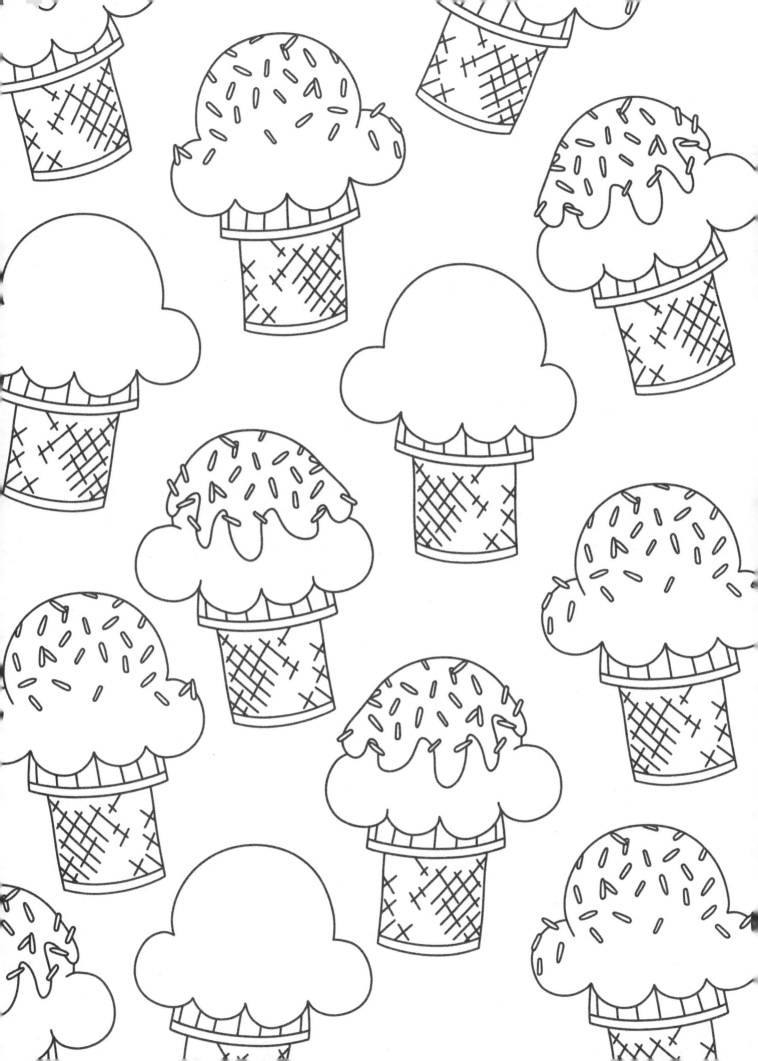

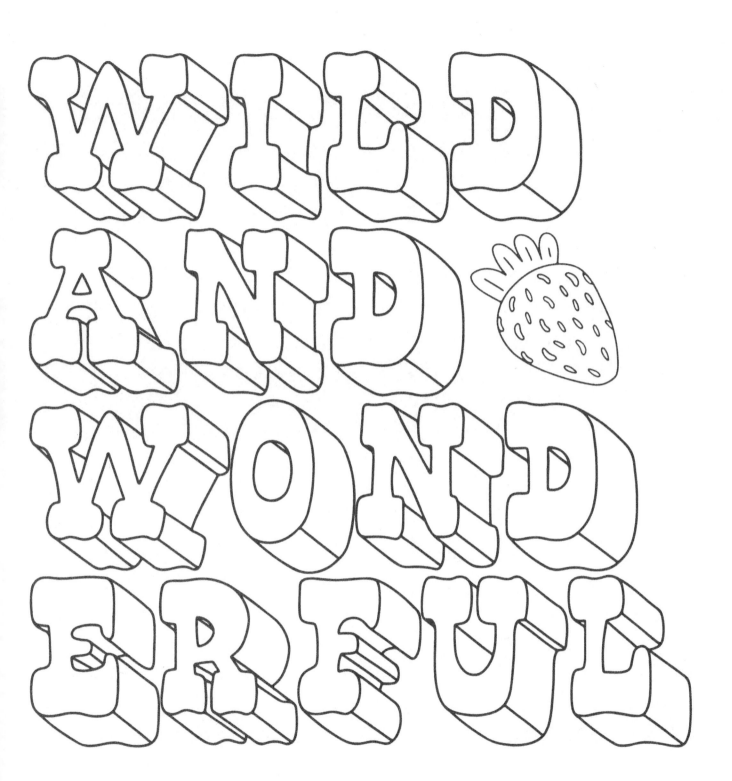

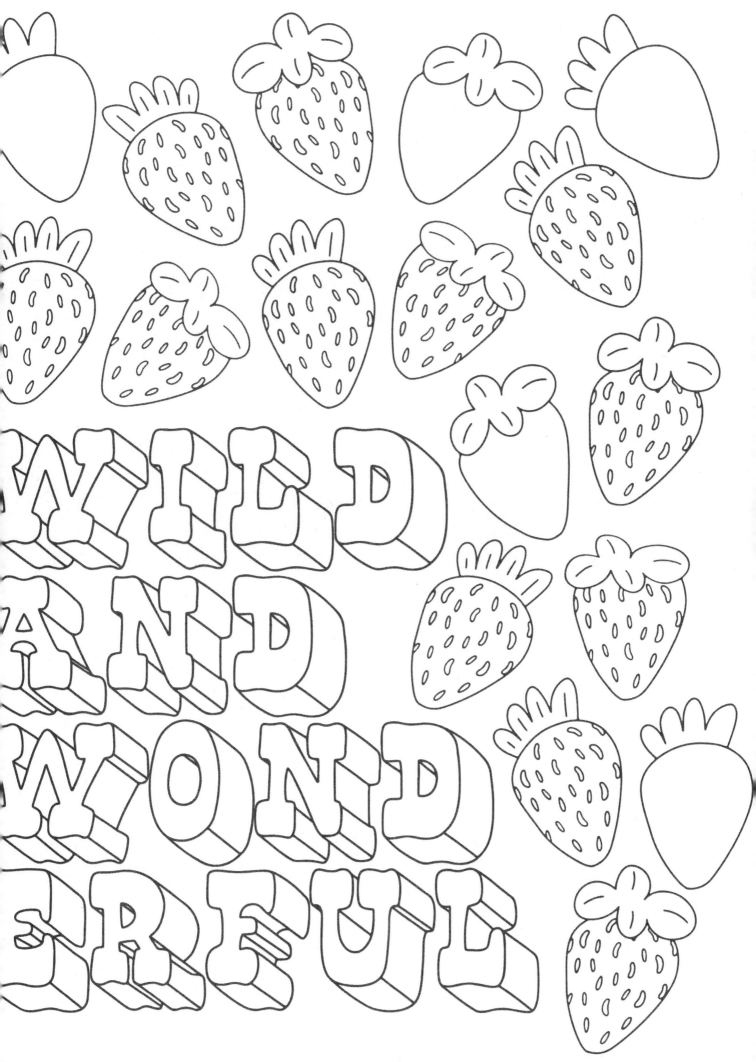

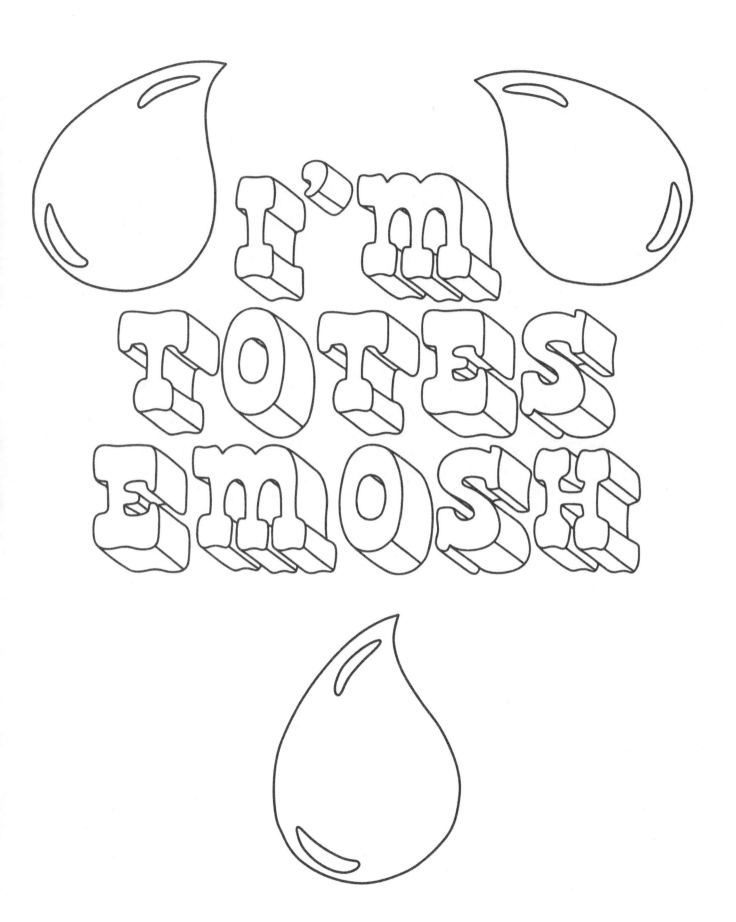

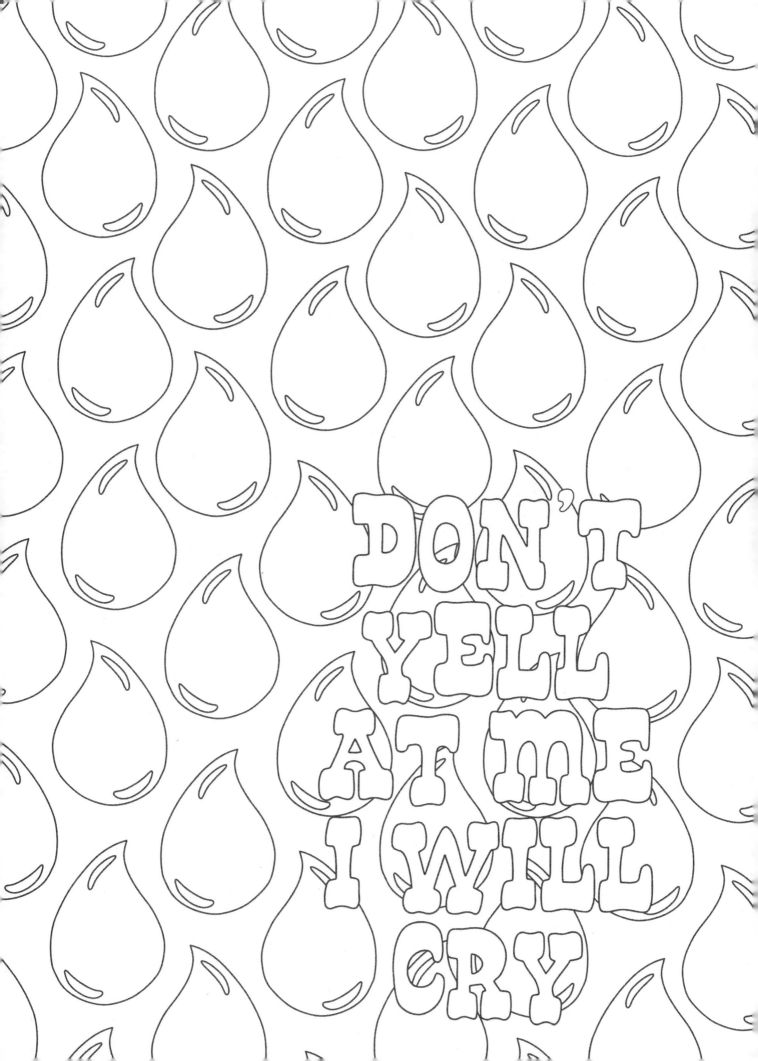

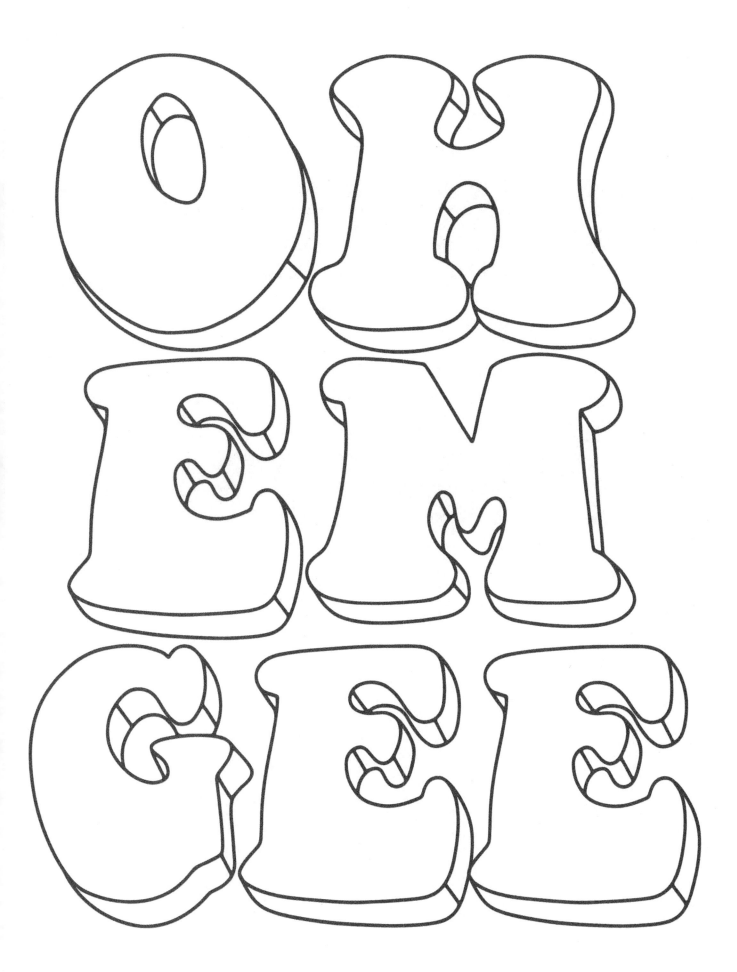

CALM YOUR TITS

NIPS SOOTHING

Made in United States
North Haven, CT
26 November 2024